Copyright © 2015 by Amanda Du Plooy

Published by CreateSpace Independent Publishing Platform

All rights reserved. This book or any portion thereof may not be reproduced or used in any manner whatsoever without the express written permission of the publisher except for the use of brief quotations in a book review.

ISBN-13: 978-1522849704

ISBN-10: 152284970X

Magic Carpet
Journey into interculturalism
by
AMANDA DU PLOOY
2014

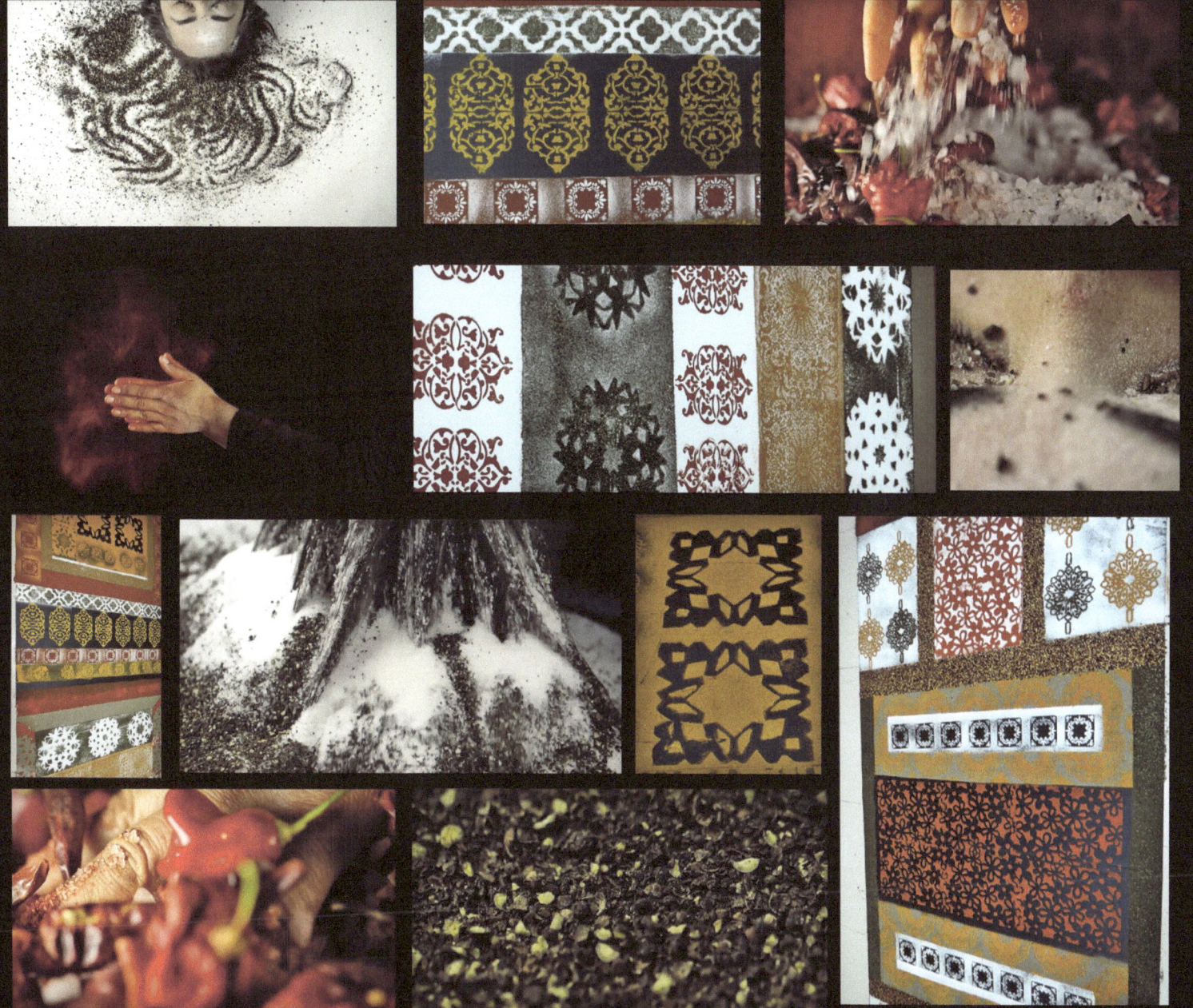

Fig 2. Amanda du Plooy, detail from Magic Carpet (2014)

CONTENTS

LIST OF ILLUSTRATIONS ... 3

MAGIC CARPET .. 8

INTRODUCTION ... 8

WHAT IS CULTURAL DIVERSITY, MULTICULTURALISM AND INTERCULTURALISM? ... 9

TRADE…COLONIZATION…MIGRATION .. 11

CONCEPTUAL CONTENT .. 13

PROCESSES ... 15

BERNI SEARLE .. 18

CONCLUSION .. 19

BIBLIOGRAPHY ... 21

CURRICULUM VITAE .. 24

ACKNOWLEDGEMENTS ... 25

List of Illustrations

Figure 1　　　　　　　　Amanda du Plooy, *Magic Carpet* (2014). Mixed media, dimensions variable. Pretoria.

Figure 2　　　　　　　　Amanda du Plooy, *Trade* (2014). Stills from triptych video, 243 seconds. Pretoria.

Figure 3　　　　　　　　Amanda du Plooy, *Culture Installation* (2014). Mixed media, 756 cm x 122 cm each. Pretoria.

Figure 4　　　　　　　　Amanda du Plooy, *Cultural Diversity* (2014). Turmeric, chilli, paprika, zaater, salt, 252 x 122 cm. Pretoria.

Figure 5　　　　　　　　Amanda du Plooy, *Multiculturalism* (2014). Pepper, paprika, chilli, zaater, turmeric, salt, 252 x 122 cm. Pretoria.

Figure 6　　　　　　　　Amanda du Pllooy, *Migration* (2014). Video Still, **seconds. Pretoria.

List of Illustrations

Figure 7 Amanda du Plooy, *Interculturalism* (2014). Paprika, chilli, zaater, turmeric, chilli flakes, pepper, salt, 252 x 122 cm. Pretoria.

Figure 8 Amanda du Plooy, detail from *Multiculturalism* (2014). Pepper, paprika, chilli, zaater, turmeric, salt, 252 x 122 cm. Pretoria.

Figure 9 Amanda du Plooy, *Colonization* (2014). Stills from triptych video, 243 seconds. Pretoria.

Figure 10 Berni Searle, *Red Yellow Brown* (1999). From the Colour Me Series, 3 Colour Photographs, 120 x 100 cm each. (Van der Watt 2004:75 Fig 1)

Figure 11 Amanda du Plooy, detail from *Cultural Diversity* (2014). Turmeric, chilli, paprika, zaater, salt, 252 x 122 cm. Pretoria.

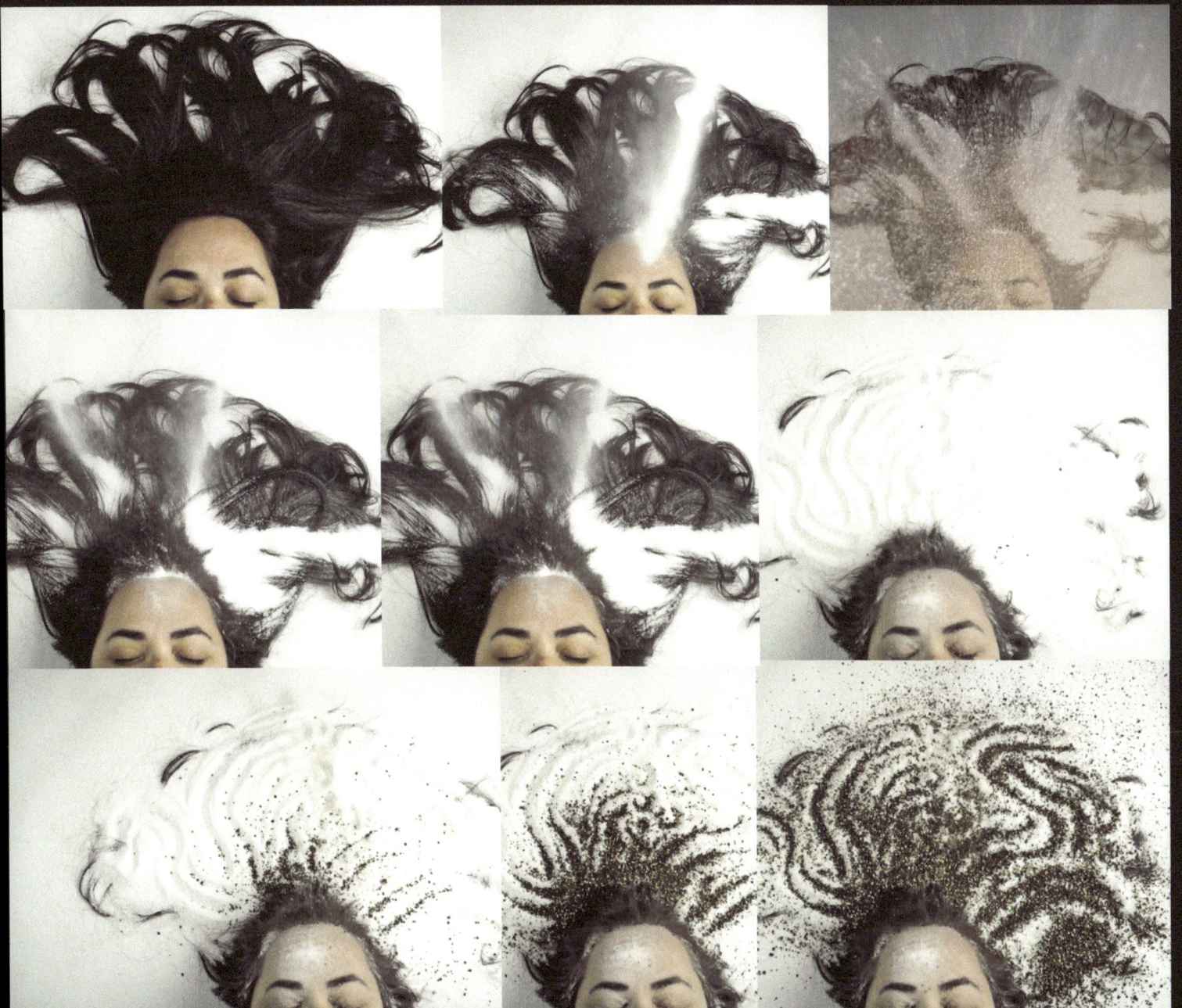

Fig 2. Amanda du Plooy, Trade (2014)

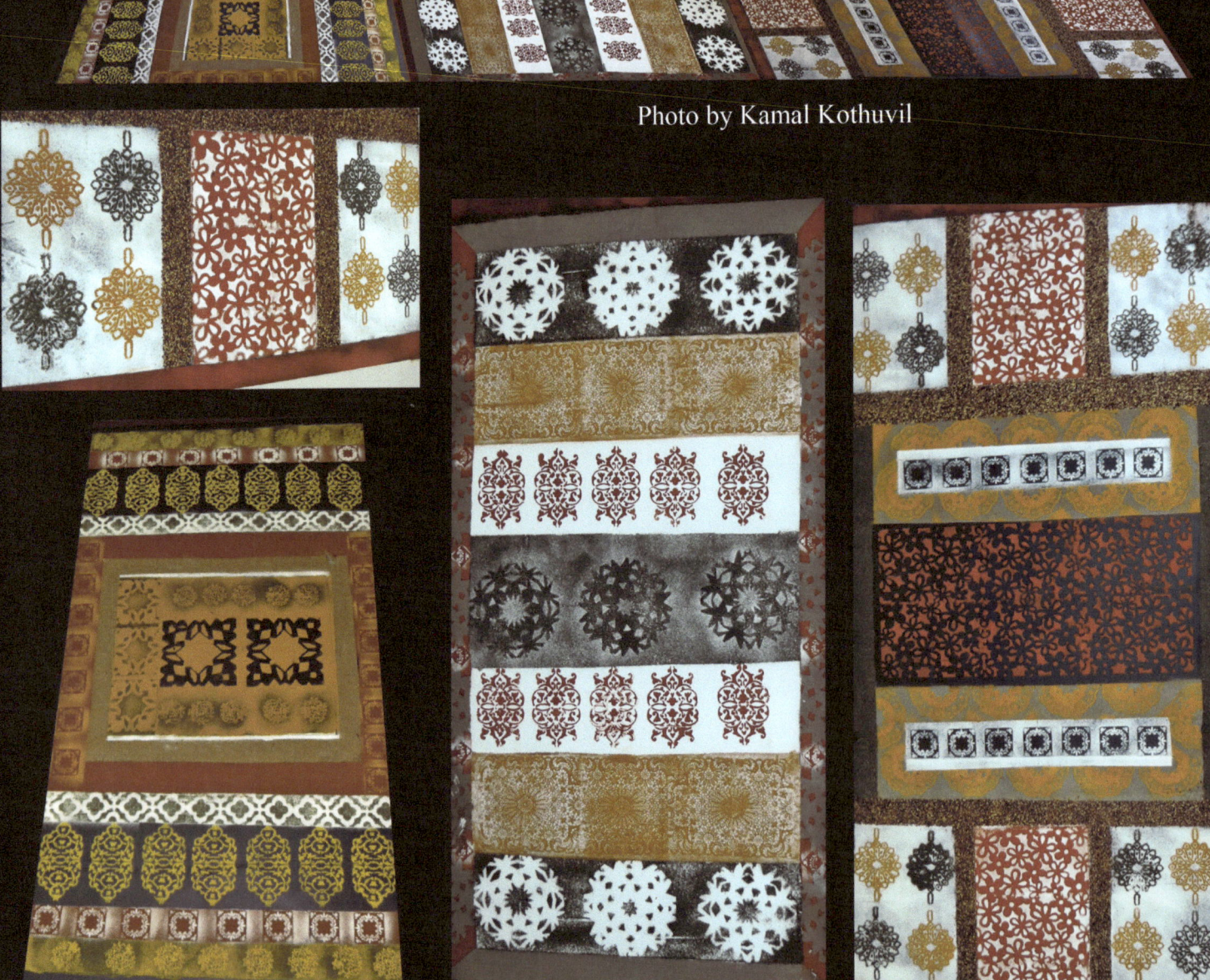

Fig 3. Amanda du Plooy, Culture Installation (2014)

Photo by Kamal Kothuvil

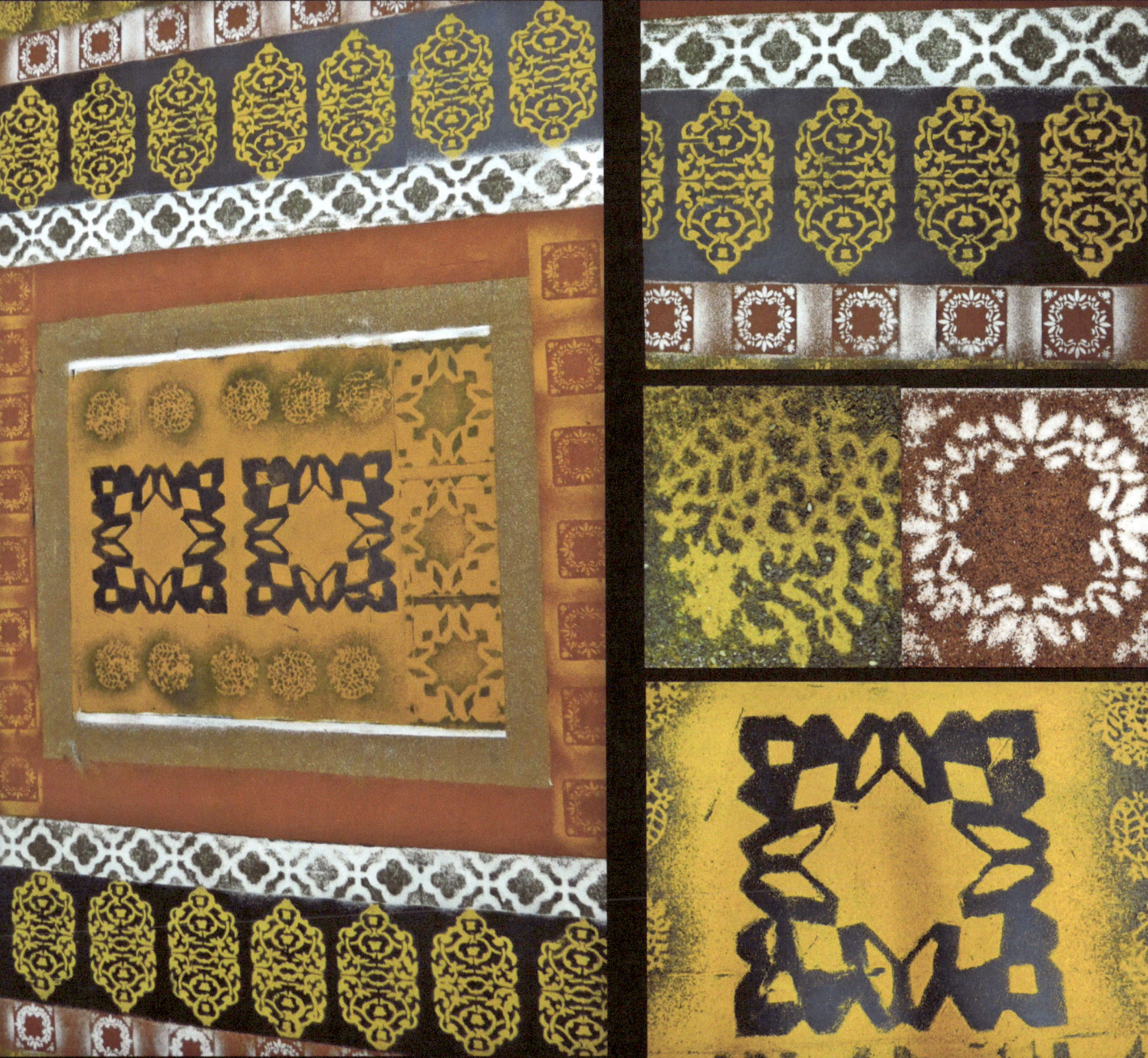

Fig 4. Amanda du Plooy, Cultural Diversity (2014)

MAGIC CARPET
Journey into interculturalism

Introduction

With an abiding interest in cultures, I've been challenged many times since 1994, as I come face to face with the world outside white Afrikaner Christian culture – South Africa: the rainbow nation. In addition, having lived in the Middle East for the past 15 years, I echo the words of Navab that states how important it is to "talk about what connects cultures and what separates them" (2014). I've been inspired by the idea that an Oriental rug is the ultimate metaphor for cultural diversity, multiculturalism and interculturalism.

What is cultural diversity, multiculturalism and interculturalism?

Cultural diversity is differentiating between customs, beliefs and attitudes. According to Pincus (2011), it could be grounded on categories of class, nationality, gender, or sexual orientation. This diversity is expressed through lifestyle. These groups are not just self-chosen, but power and structure often play a role in forming them (Jindra 2014:317).

Multiculturalism as a descriptive term, is culturally diverse communities living within one specific society. As an ideological term it highlights cultural recognition (Sutherland 2008:75) and aims to preserve cultural heritages and histories (Cantle 2012).

"Interculturalism presents a new set of policies and programmes that seeks to replace multiculturalism and provide a new paradigm for thinking about race and diversity" (Cantle 2012). Rather than being defined by our separate past heritages or histories, it is about evolving, changing and thinking.

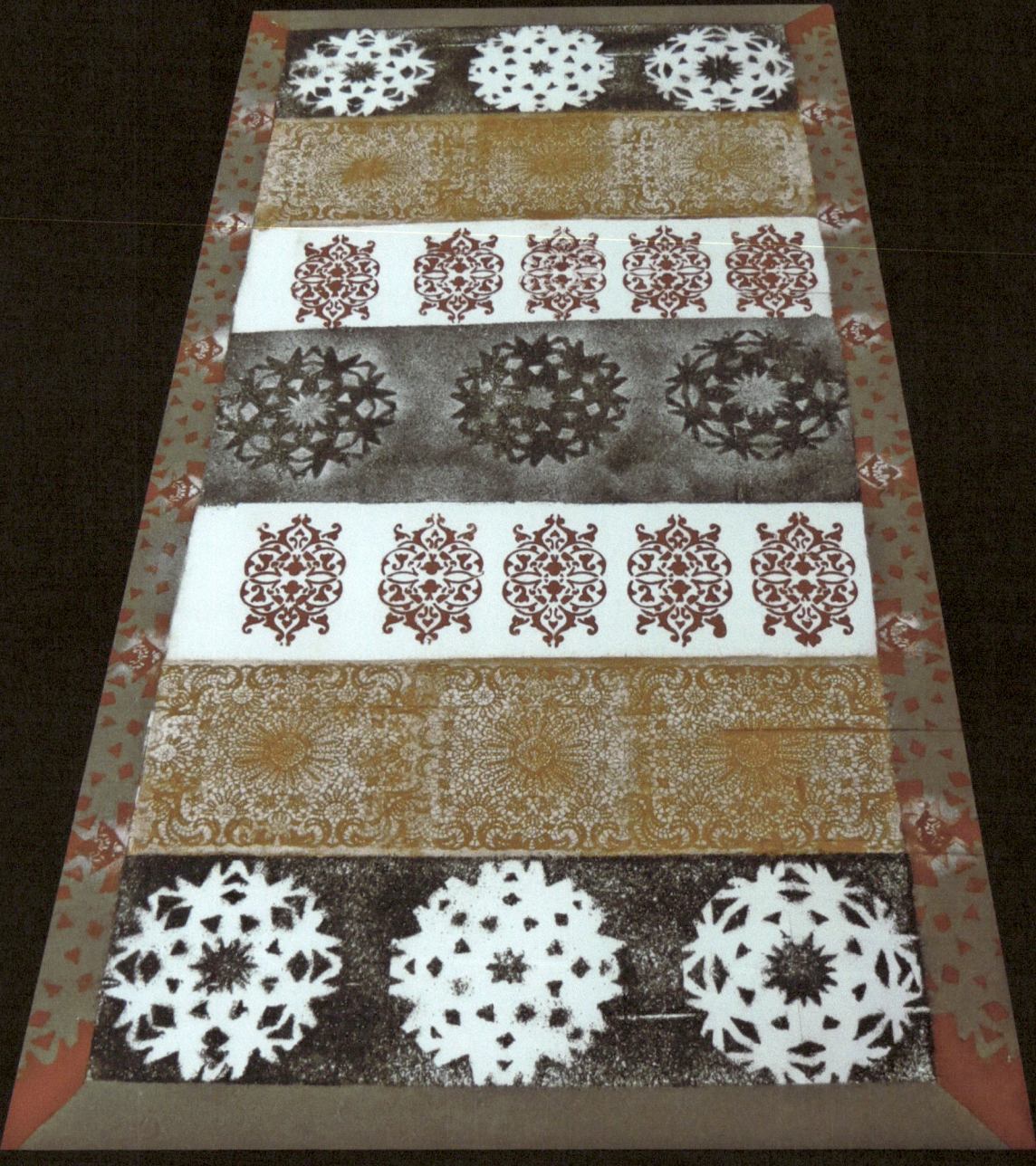

Fig 5. Amanda du Plooy, *Multiculturalism* (2014)

TRADE…COLONIZATION…MIGRATION

I believe that the fundamental reasons for the cross pollination of cultures are migration, colonization and trade. Trade was one of the first things that caused man to move around geographically and come into contact with other cultures. The earliest traces of trade can be found with the buying and selling of salt[1]. After that pepper was the most valuable commodity (Versfelt 2005).

Trade eventually made way for the dawn of Colonialism. As spices were traded with exotic places, westernized countries discovered its rich resources and came up with pre-texts to colonize those countries. The colonization of countries brought about culturally diverse societies (Cornillez 1999).

Migration describes people leaving their home country, relocating to another and acquiring citizenship of a new country. It mostly happens trust is lost in governments and authorities (Giddens 2007).

My opinion is that our evolutionary drive to find greener pastures have made trade, colonization and migration predetermined factors and cross pollination of cultures unavoidable.

[1] http://www.saltworks.us/salt_info/si_HistoryOfSalt.asp (Accessed 13 July 2014)

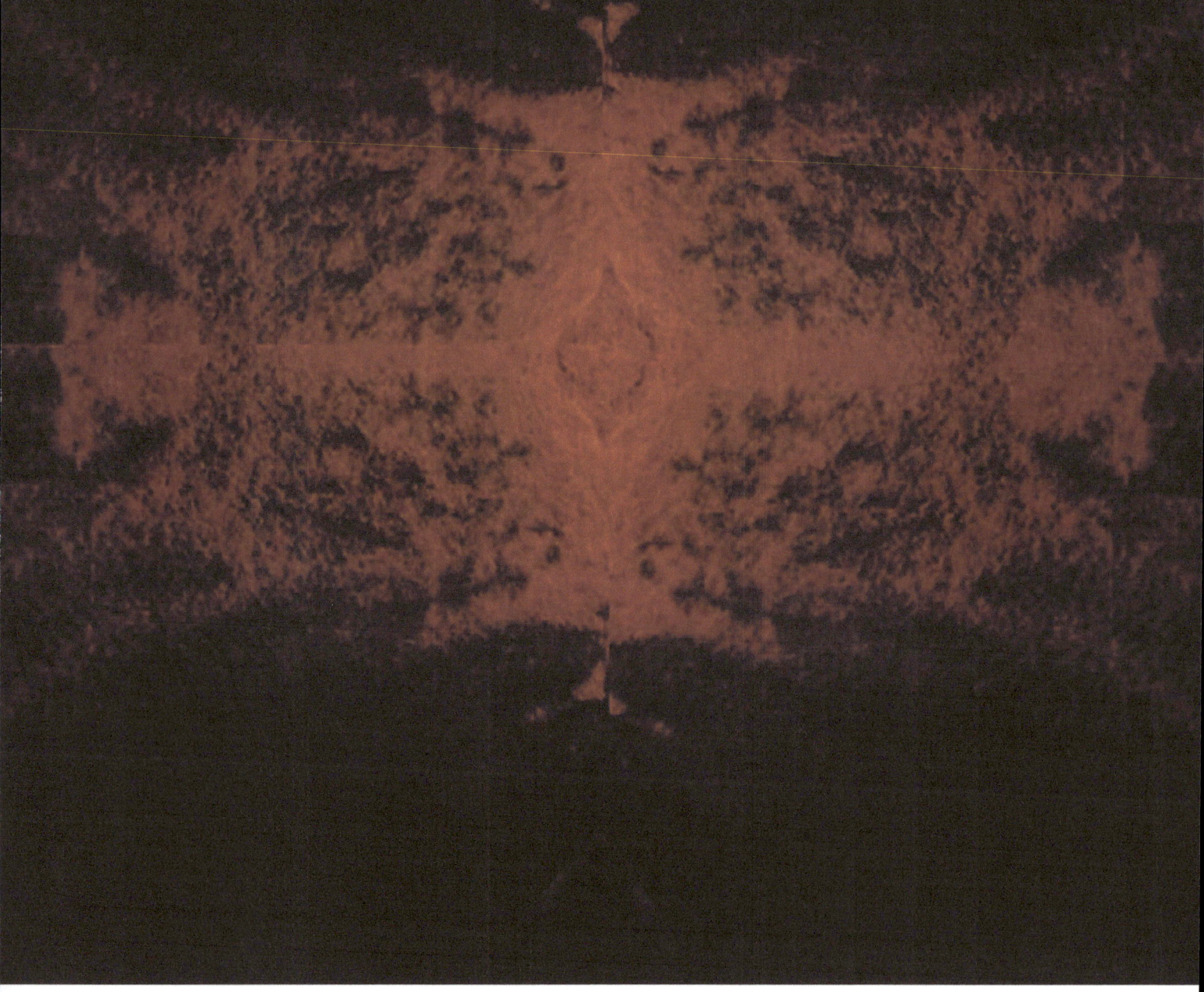

Fig 6. Amanda du Plooy, Migration (2014)

CONCEPTUAL CONTENT

My artwork extends the ideas of interculturalism. For example, we cannot say that South Africa's identity is A or B, or even A & B and will forever remain that way. Our constitution and the values of Ubuntu (which says "I am because we are") does not allow it (Mangaliso et al. 2001:32). We are all the time evolving due to our diversity and the constant flow of newcomers.

The exhibition consist of site-specific transient spice rug installations and video projections. The metaphor of the Oriental rug references interculturalism and spice represents (through its history) the exploration of the relationship between the outer (economic aspirations) and the inner (faith and culture) world. Its transient nature comments on the origins and nature of cultural diversity, multiculturalism and interculturalism.

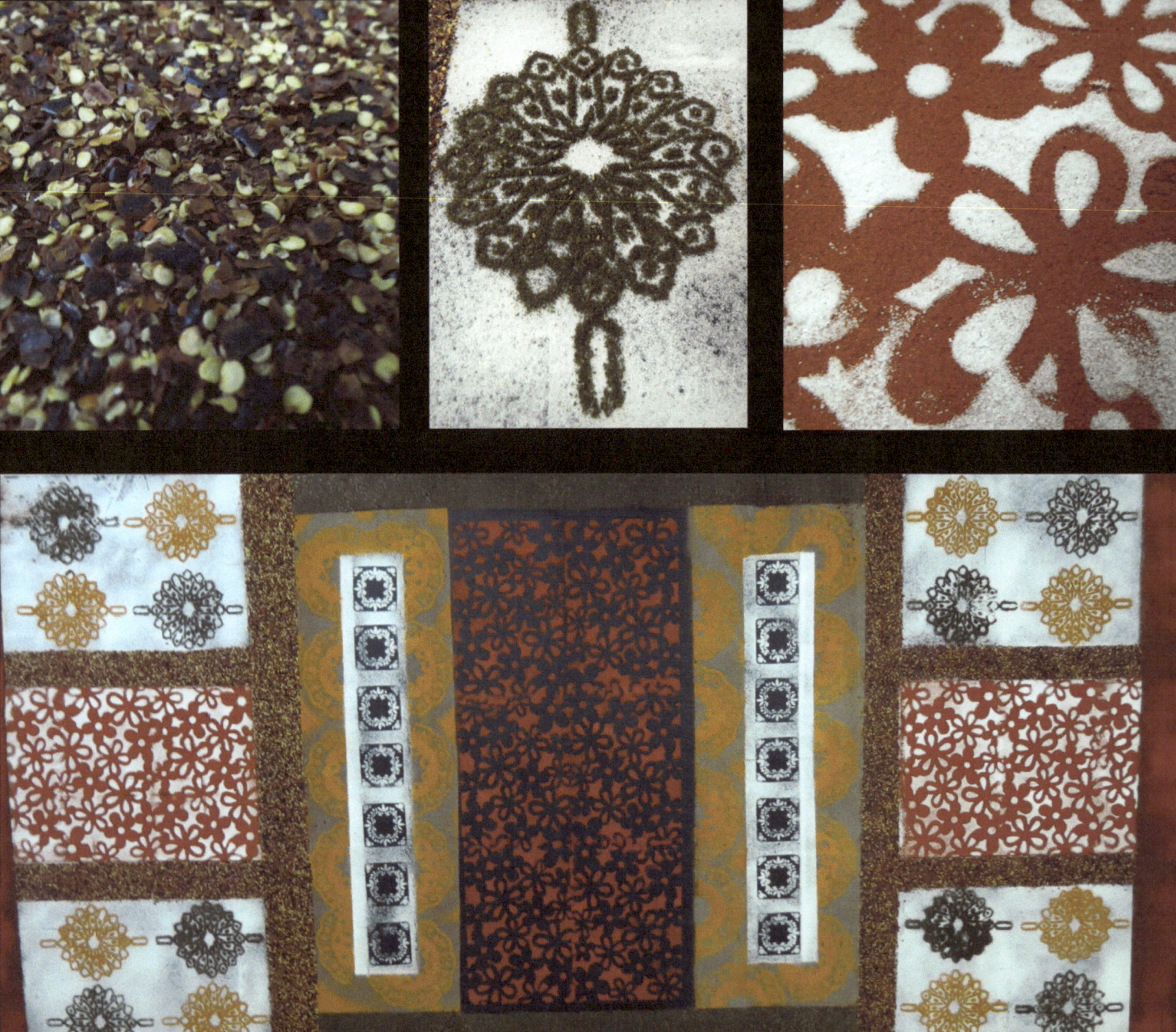

Fig 7. Amanda du Plooy, Interculturalism (2014)

PROCESSES

I looked at the colours and intricate geometric patterns typically found in oriental rugs and used them as inspiration to emulate richly woven carpets. I looked extensively at the use of scale, texture, tonalities and space. I collected, categorized and explored (through seeing, touching, tasting, smelling) various spices. The work has a lyrical element but it is curbed by the smell and micro particles floating in the air which will stealthily start to overwhelm the viewer.

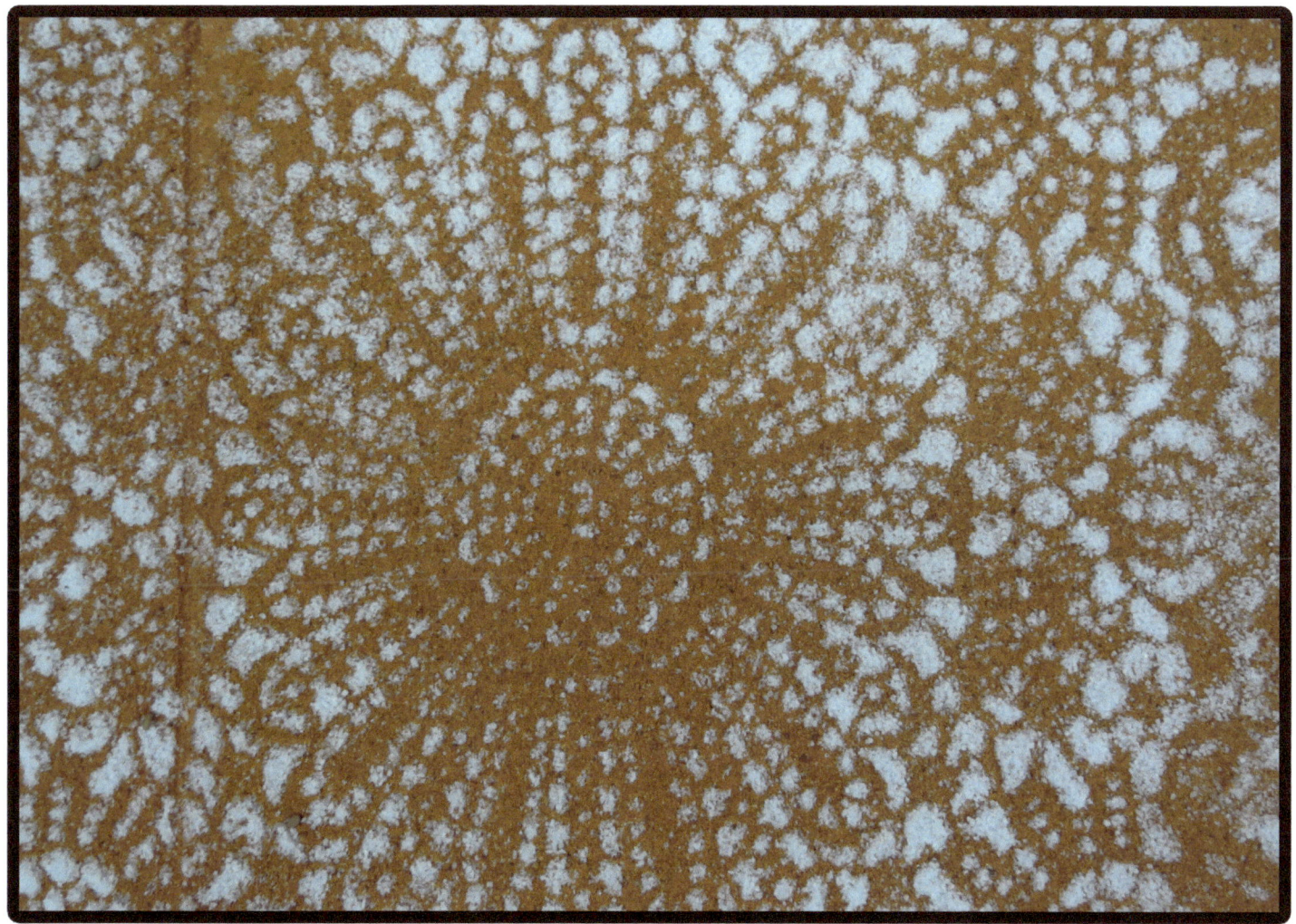

Fig 8. Amanda du Plooy, detail from Multiculturalism (2014)

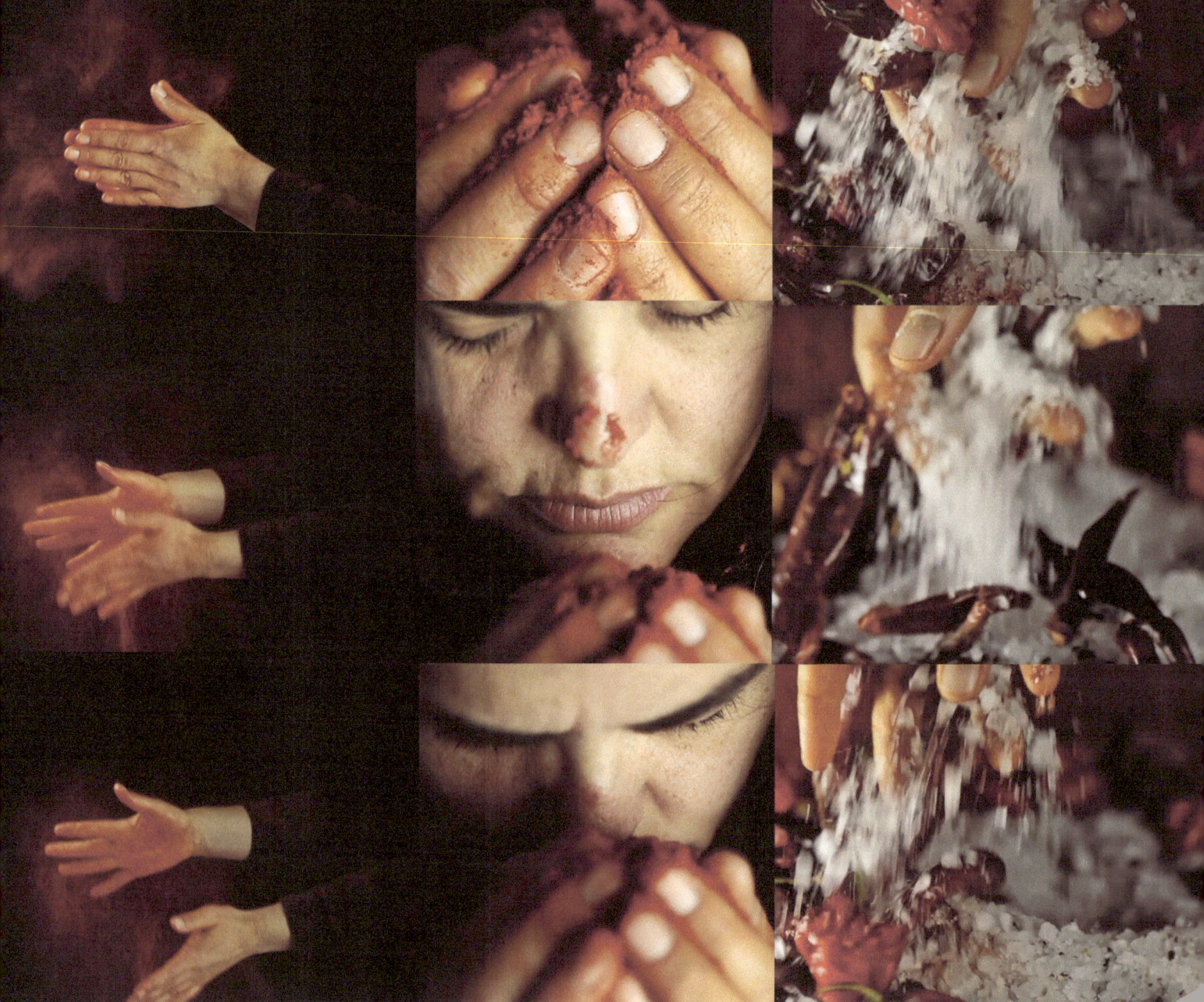

Fig 9. Amanda du Plooy, Colonization (2014)

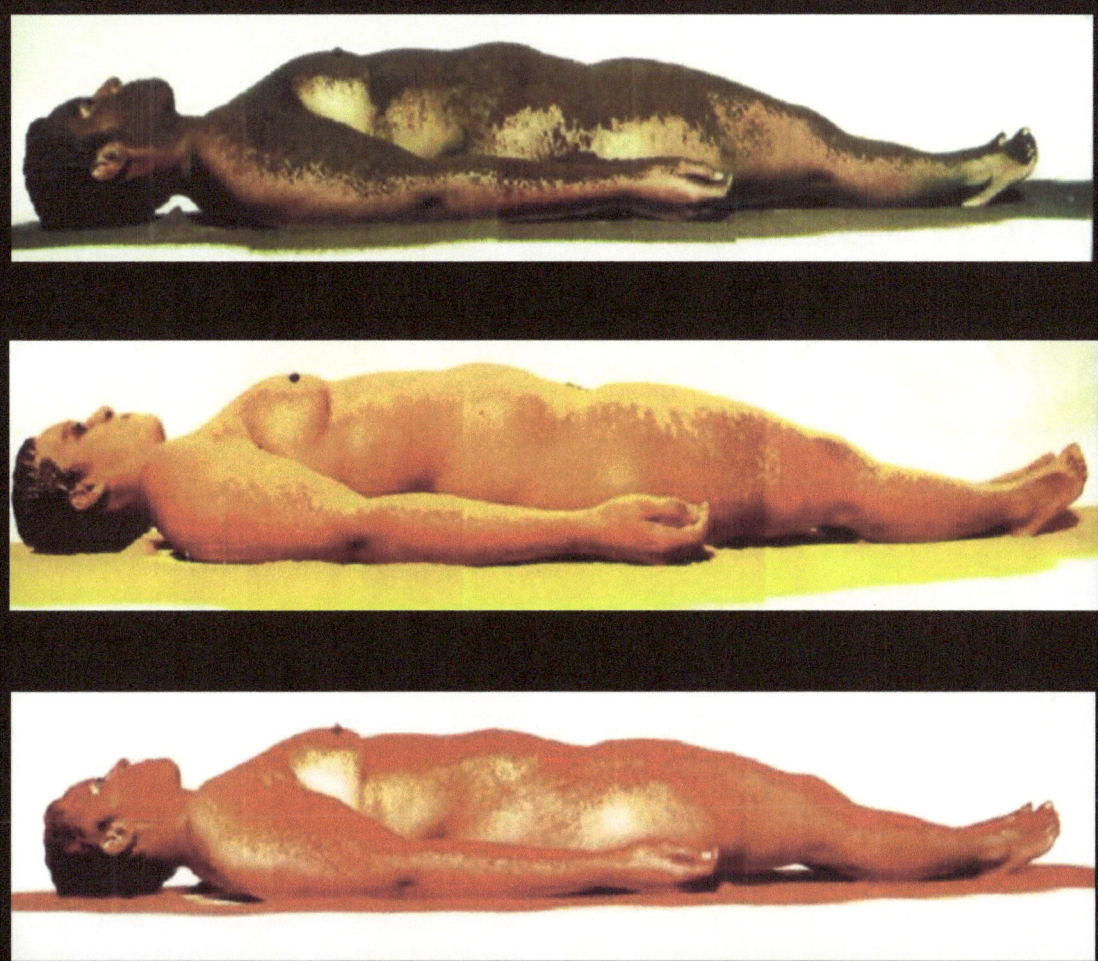

Fig 10. Berni Searle, *Red Yellow Brown* (1999)

BERNI SEARLE

The artist who has influenced my work is Berni Searle. Her work is based upon a reflective life, lived from cultural diversity and multiculturalism into interculturalism through the South African context (Murinik 2001:76).

Red Yellow Brown (1999), from the Colour Me Series (Van der Watt 2004:75) features digital prints of her naked body covered or surrounded with spices. The work reflects "the infinite types of visual play that happen in these spaces upon the nature of representation; scrutinizing issues of race and racial naming… and invokes questions and observations around… the exoticism of difference" (Murinik 2001:77).

My work relates to Searle's, for her use of spices and for how her artwork embodies the possibilities during cultural transformation.

Conclusion

Being from South Africa and living abroad I have come to the realization that cultural diversity inevitable and always will be a daily reality for all of us. Nations will have to understand interculturalism in order to cope with tensions between cultures.

The history and the characteristics of the spices in the projections, as well as the ephemeral quality of the installation work comments on networks, intersections, procedures present during the evolution of cultures.

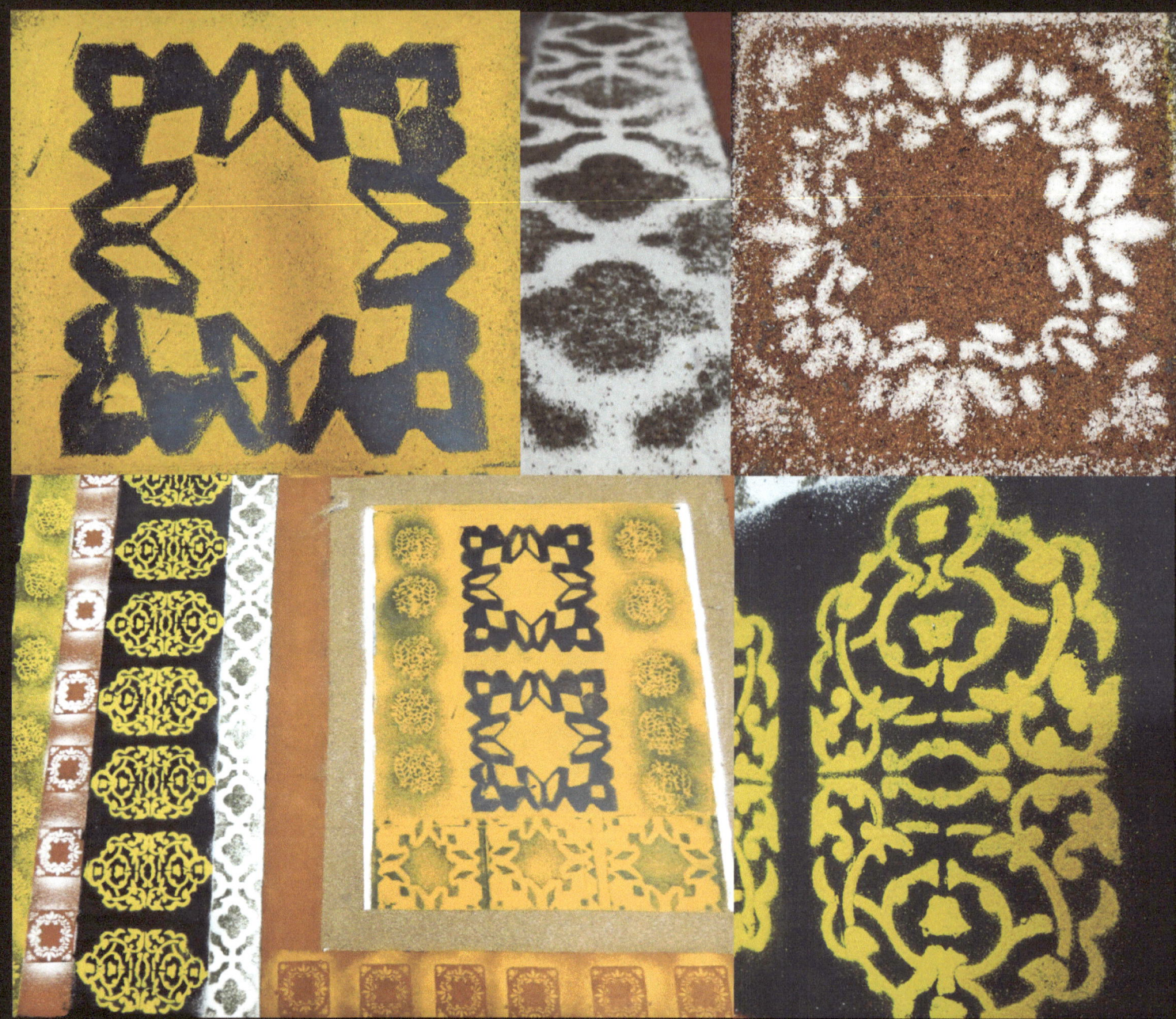

Figure 11. Amanda du Plooy, detail from *Cultural Diversity* (2014)

Bibliography

Cantle T. 2012. Tedcantle.co.uk Sv "Interculturalism". http://tedcantle.co.uk/resources-and-publications/about-interculturalism/ (Accessed 27 August 2014).

Cornillez, L, M, M. 1999. Postcolonial Studies @ Emory Sv. "Spice trade in India" http://postcolonialstudies.emory.edu/the-history-of-the-spice-trade-in-india/ (Accessed 13 July 2014).

Giddens, A. 2007. The Guardian. Sv "Robert Putnam" http://www.theguardian.com/commentisfree/2007/oct/30/debatingdiversity (Accessed 28 August 2014).

http://www.saltworks.us/salt_info/si_HistoryOfSalt.asp (Accessed 13 July 2014).

Jindra, M. 2014. The Dilemma of Equality and Diversity. *Current Anthropology*, 55(3), June:316-334.

Mangaliso, M. P. & Damane, M. B. 2001. Building Competitive Advantage from "Ubuntu": Management Lessons from South Africa [and Executive Commentary]. The Academy of Management Executive 15 (3), August:23-24.

Murinik, T. 2001. Berni Searle. *Journal of Contemporary African Art*, 13(14), Spring/Summer:74-79.

Bibliography

Navab, F. 2014. The Rug metaphor Sv. "Oriental Rug" http://www.navabbrothers.com/gaz_rugmetaphor.html (Accessed 13 July 2014).

Pincus, FL. 2011. Understanding Diversity: *An introduction to class, race, gender, sexual orientation, and disability*. Boulder: Lynne Rienner.

Sutherland, PD. 2008. A Golden mean between Multiculturalism and Assimilation. An Irish Quarterly review, the family today, 97(385), Spring:73-86.

Van der Watt, L. 2004. Tracing Berni Searle. *African Arts*, 37(4), Winter:74-96.
Versfelt, M. 2005. A peppered past. *The Herbarist*, 71, 48-51.

Amanda du Plooy, photograph taken by Kamal Kothuvil (2014)

Curriculum Vitae

Date of Birth:	1969 South Africa
Nationality:	South African
Place of Residence:	United Arab Emirates
Language proficiency:	Afrikaans, English, Dutch, Arabic and basic German
Education: 1987	Matriculation, Hoërskool Transvalia, Vanderbijlpark
1994	Diploma in Public Relations, Damelin International College, Pretoria
1998	Diploma in TEFL, Randpark International Language Institute, Randpark
2012	Diploma in Modern Standard Arabic, Al Jazeel Language Institute, Bureimi Oman.
2015	Bachelor of Visual Arts, University of South Africa
	Awarded: Certificate of Excellence
Contact:	E-mail: amandaformail@generalmail.net

Selected exhibitions

June 2013	Group exhibition - Creation, Rihan Heights, Abu Dhabi
March 2014	Group exhibition – Faith, Cristal Hotel, Abu Dhabi
December 2015	Group exhibition - Unisa Art Galley, Pretoria.

Acknowledgements

I would like to thank the following people without whose help I could not have done it:

Dr Ania Krajewska - Course Director, for guidance and direction.

Stephanie Carlson - for proofreading.

Marius du Plooy - for support and inspiration.

Vincent Boonzaaier - for his expertise in videography and editing.

Joke Viljoen - for her support and inspiration.

Vincent at work, photograph taken by Amanda du Plooy (2014)

For Marius – my inspiration

www.ingramcontent.com/pod-product-compliance
Lightning Source LLC
Chambersburg PA
CBHW041306180526
45172CB00003B/994